Hiapo

A COLLECTION OF PATTERNS AND MOTIFS

Cora-Allan Wickliffe is of Niuean and Māori descent,
her grandparents Vakaafi Lafaiki and Fotia Lafaiki
grew up in the villages of Liku and Alofi, migrating to
Auckland in the 1960's. As a contemporary hiapo
practitioner, she produces traditional pieces alongside
her simplified modern hiapo works. Cora-Allan works
and lives in Waitākere with her fiancé Daniel Twiss
and children Chaske-Waste and Wakiya-Wacipi.

Published by Little Island Press, Auckland,
Aotearoa/New Zealand. littleisland.co.nz

202009201347

ISBN 978-1-877484-47-6

Hiapo

A COLLECTION OF PATTERNS AND MOTIFS

Cora-Allan Wickliffe

Notes by Fotia Lafaiki

This book is dedicated to Tagata Niue
and to all of my family.

CONTENTS

INTRODUCTION

Niuean hiapo (barkcloth) is like a time capsule giving you an artist's interpretation of the land, the sea and the people from their era. Each pattern is determined by the maker, and how they see a flower, leaves and patterns from traditional weaving or carving. This contributes greatly to the diverse compositions of traditional hiapo, making it look noticeably different from other Pacific barkcloth.

Traditionally, in Niue knowledge is passed down through the blood line. However, I do not want to risk having another generation grow up without the knowledge of hiapo. The patterns within these pages have been collected during my hiapo journey, and have come from many hours of research and conversation. When I started my journey I did not have the privilege of information being readily available, which is why this book is so important. I hope it is a useful tool, and that in years to come the next generation of hiapo practitioners will continue to document the land, the sea and the people of their time.

LAND

Kause Kula – Red

Kause Oga – Yellow

Kause Sea – White

Hibiscus- Kaute

The bark was traditionally used to make Hiapo.

ata

Bush weeds

"lots of flowers on the side of the road. They didn't all
have different names, we just called them flowers."
– Nana

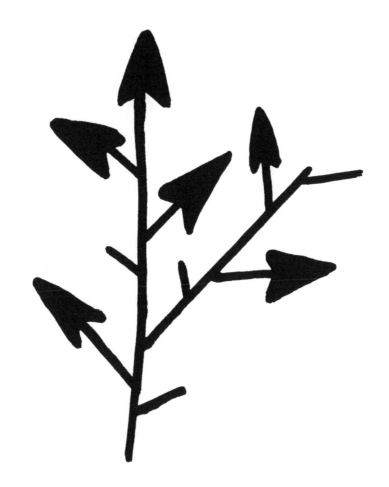

Kofetoga

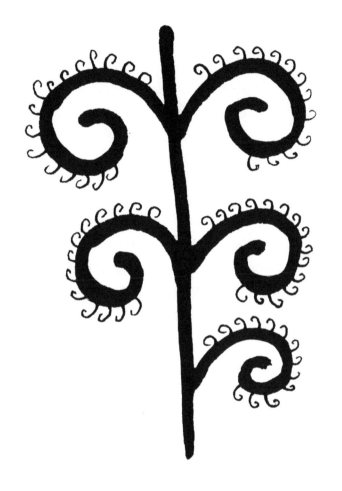

Kapihi

"One day after fishing Grandpa got sick
and I didn't know what to do. So I smashed up some
vines in a white cloth and then mixed that with warm
water. He felt better after that."
– Nana

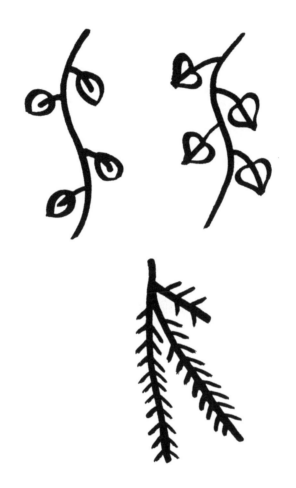

Vines - Creepers

Used for Hiapo when you don't have
the other trees available.

Bark is used to help asthma and eczema.

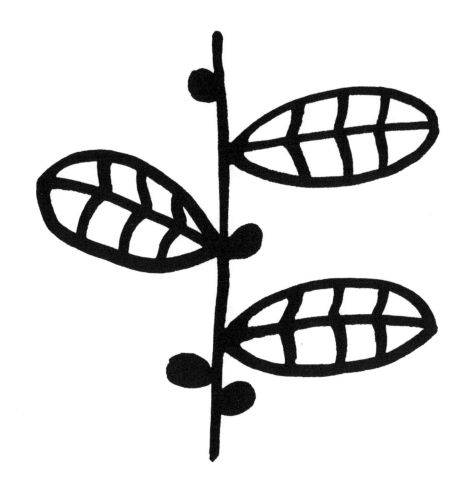

Banyan – Ovavo

Bright red flowers that look like a large pine cone.

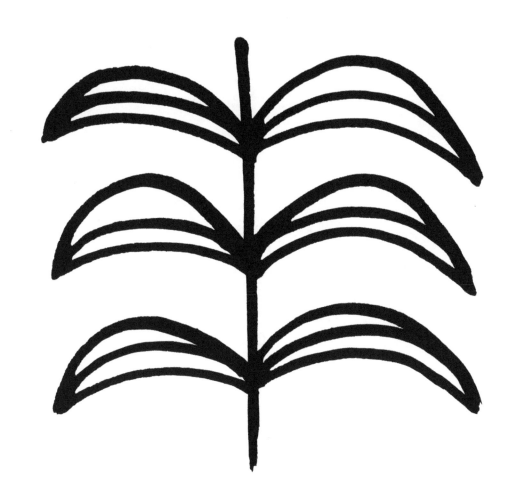

Poloi

Yellow with a hard shell.

"Rene Richardson makes a beautiful passionfruit
sponge cake using the passionfruit in her garden that
her husband grows."
– CA

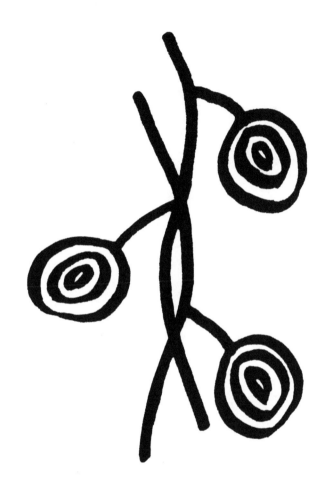

Passionfruit

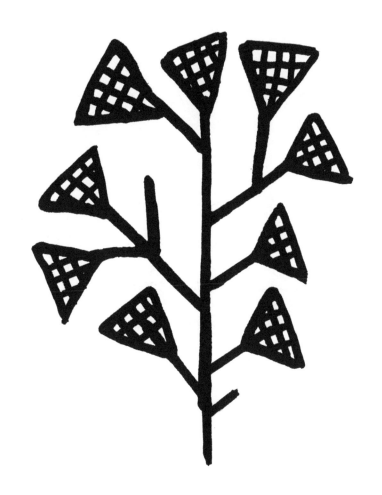

seed pods - Buds

Kahoa Lagakali

Fisi Lagakali

Strong floral scent.

"Manogi means it smells nice."
– Nana

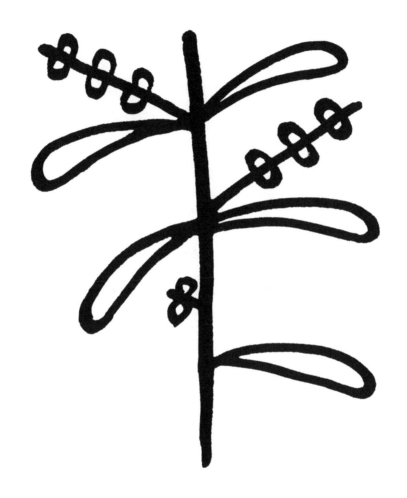

Lagakali

Fua Mei

Mei Mafala

"Used to make lots of things, chips, pitako,
bake in the oven or the umu."
– Nana

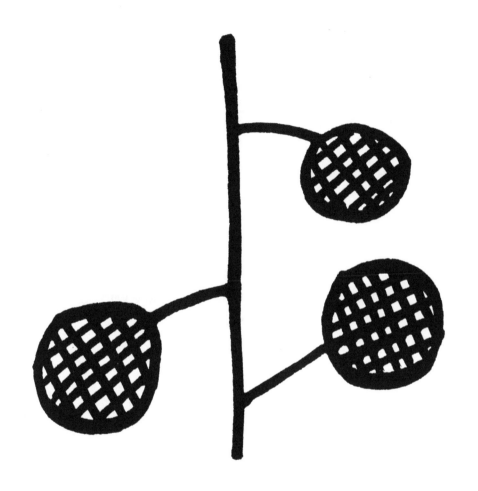

Breadfruit - Mei

A fruit with sharp kind of pointy seeds inside.

"When I would feed the pigs, I would steal the
neighbours Vi because they didn't share with us."
– Nana

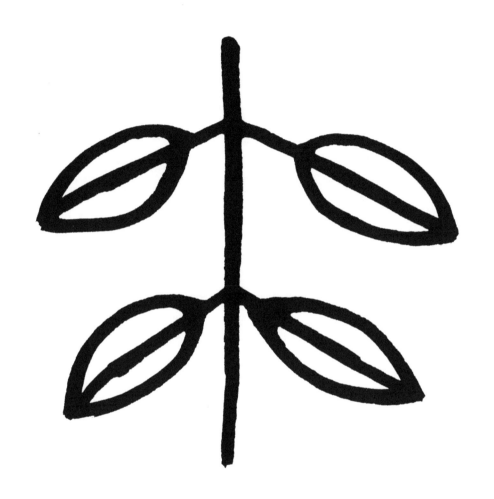

vi

Rose Sea – White

Rose Fuahoi – Purple

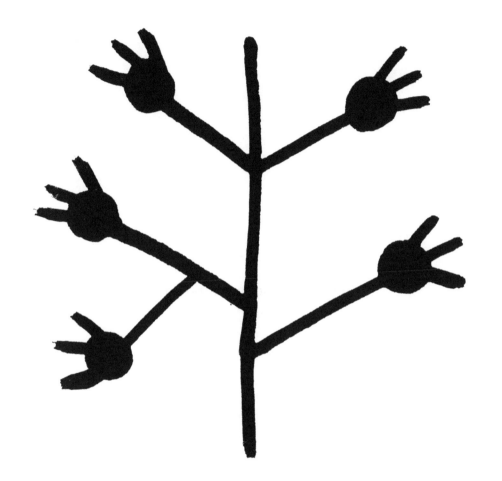

Rose

Used in carving.

Peka (bats) like to eat the fruit.

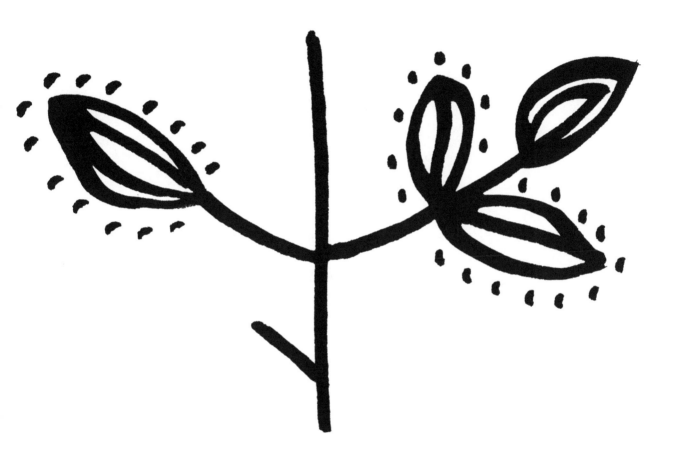

Kafika

Used to poison or stun the fish at sea.

Kohuhu Sea – White flower

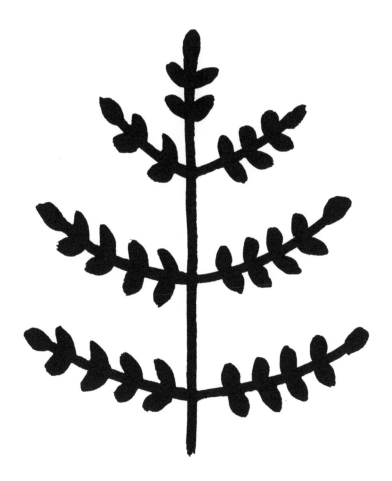

Kohuhu

The soot is used to make Hiapo ink black.

You can eat the nut; it also makes oil.

Traditionally used for lighting, like a candle.

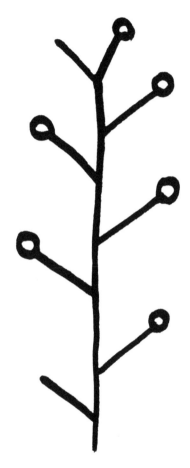

Tuitui bud - Candlenut

Used to make Sisi (skirt) after you strip
the fibres and soak them at sea.

Used to make Kahoa (necklace).

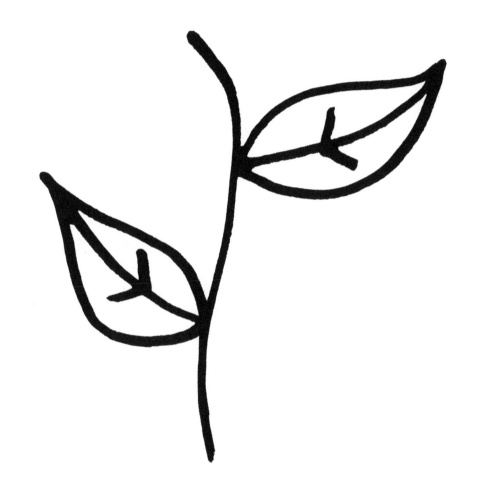

Fou Laina

"We use to have a white one we brought to
New Zealand from Niue. But Grandpa shifted
it from the back to the front and it died."
– Nana

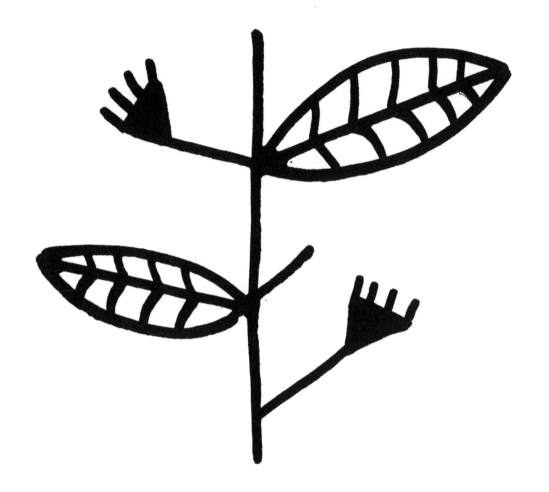

Tiale – Frangipani

"Lots of flowers in Niue, we put them in
our ears. We would bring seeds over
from Niue and grow lots in our garden."
– Nana

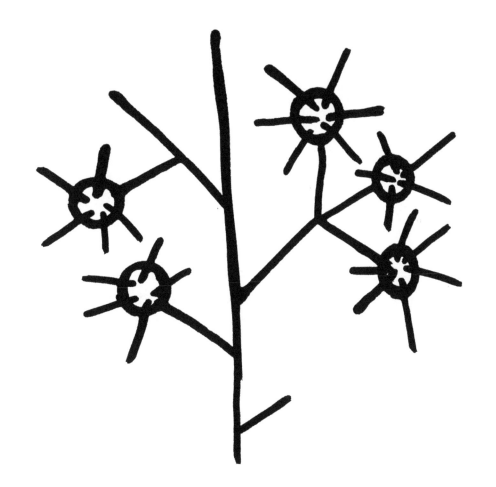

Tiale Feutu

Use for food, oil, broomstick and used
to weave lots of things.

"Aunty Famili wove a coconut frond basket
at the Liku show day during the women's
weaving race. She came third and won $10."
– CA

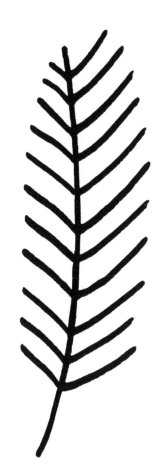

Niu — Coconut

Ufi lei

Ufi fuahoi

Ufi Sea

Cook it like a potato

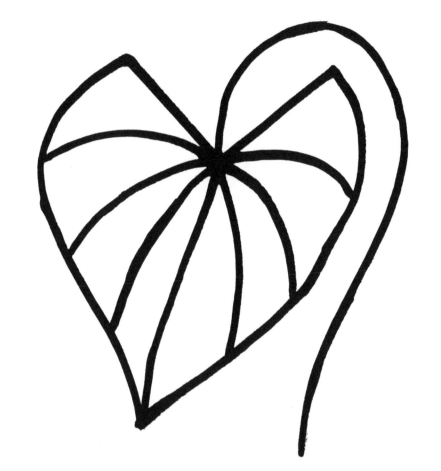

Ufi - Yam.

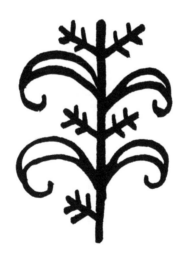

Ferns

Burn the leaves and collect the ashes, mix with oil
creating a paste to heal wounds/burns.

The trunk is used to cook food inside.

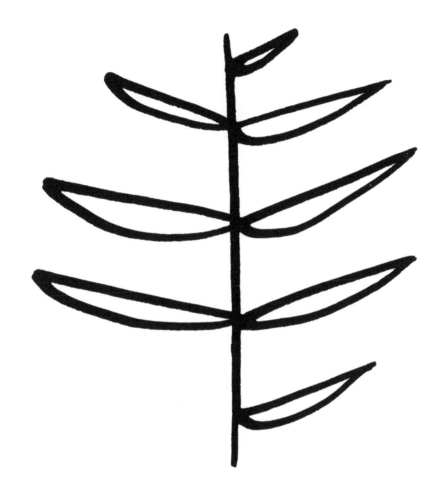

Bamboo - Kaho

Purple pink flowers with dark green pointy leaves.

"I use to make the oil smell nice all the time.
You just add flowers to scraped
coconut oil, then leave them in the sun."
– Nana

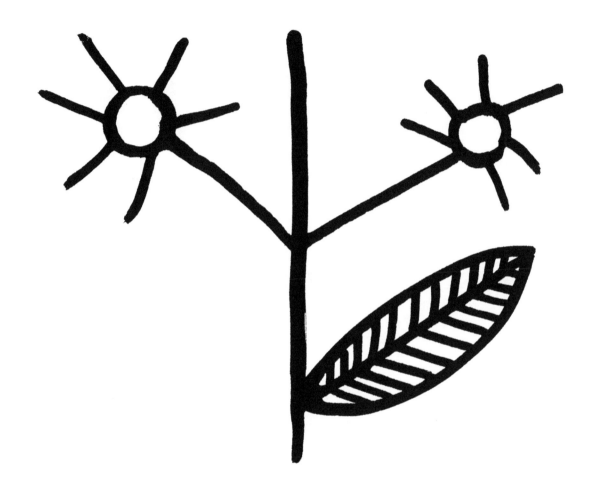

Talona

Little yellow flowers

Tona tona

We use to chew on the kava plant
leaves to help out mouth ulcers.

A drink is made from the roots of the plant.

Kava

Akau Pomea

Bright red seeds.

Roast like a peanut.

Pomea Mataila - Crabs eye

Talo

Taro

"Grandpa use to peel it by holding
it with a tea towel so his hands
wouldn't get itchy."
– Nana

Talo

Felila fisi fuahoi

Purple round flower.

Felila

Use different ferns for different things

Luku fua used in cooking

"We used to make temporary shelter with
Lukula when we had to sleep in the bush
over night because it was too far to
return home."
– Nana

Lukula- Birdsnest fern

Si – Ti

Roots used for medicine.

Leaves can be used for a Kahoa or Sisi.

Bake and Chew – tastes sweet.

Ti

Maile used to make a Kahoa.

"We received these when we landed
in Niue from Moka, we stayed at the
Alofi back packers."
– CA

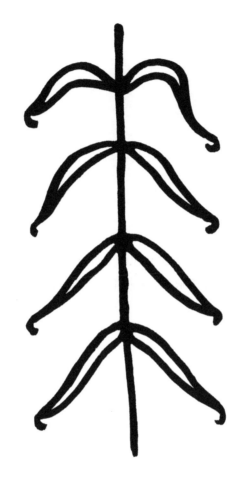

maile

Soak in hot water to make it softer
to poke a hole for a necklace.

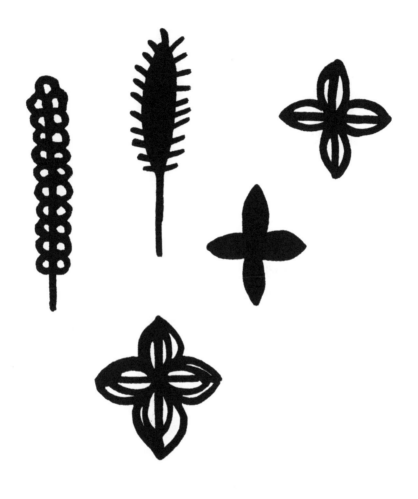

Seed Pods

Good to use for sugar.

"We use to grow lots of it, but then
Grandpa cut them down because
we didn't harvest them enough and
he planted other things."
– Nana

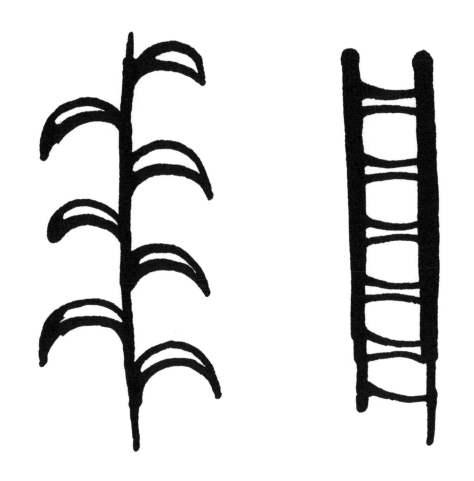

Sugar cane

Birds eat the seeds.

Fruit is sweet to eat when its ripe.

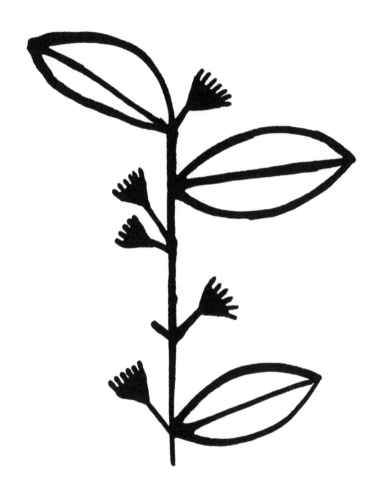

Kolivao

Used to make oil and necklaces.

Smells fulufulu ola (beautiful).

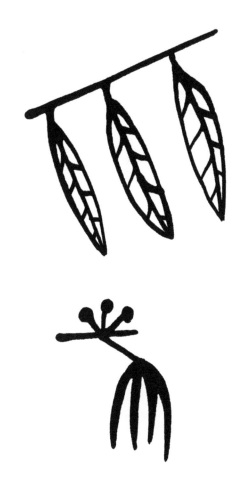

Motōi — Ylang Ylang

Fā is used for weaving mats, baskets.

The roots are used for medicine.

The seed is used to paint Hiapo.

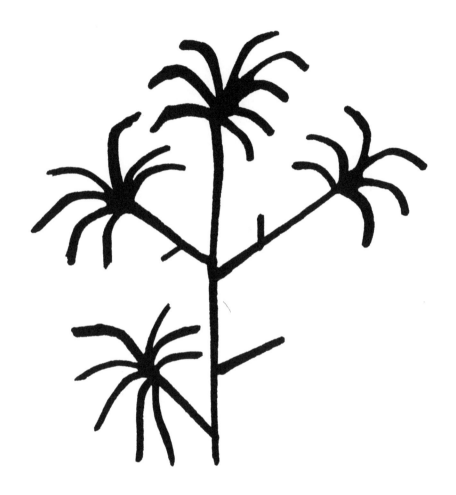

Fā — Pandanus

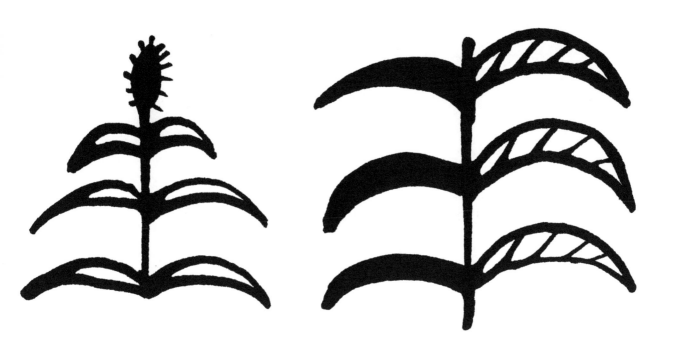

Keuila

The leaves are really huge, used for decoration.

Kape - Giant Leaf

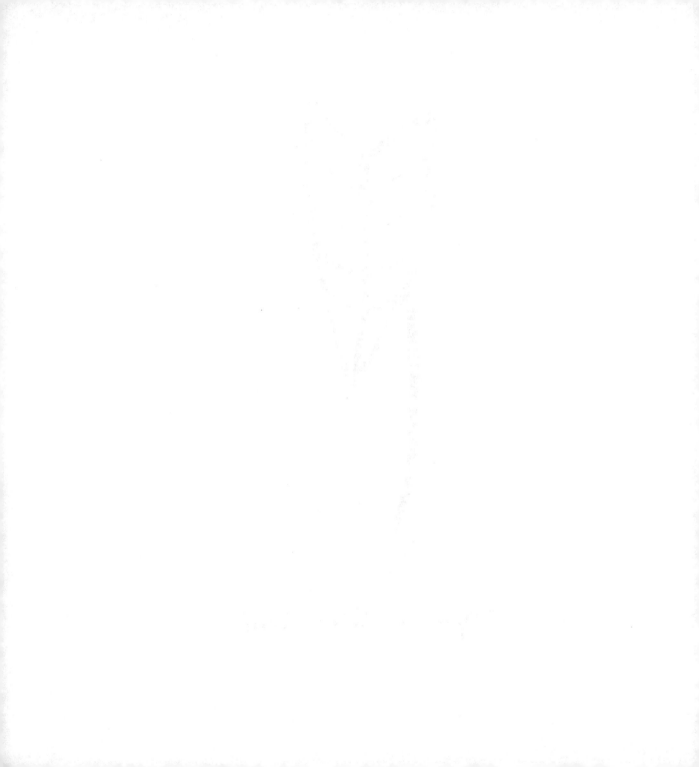

SEA

"I don't know many stories about sharks,
but there are so many different fish to eat in Niue."
– Nana

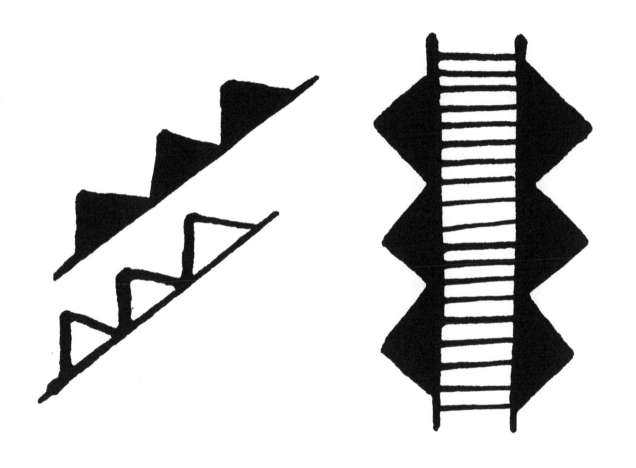

Sharks teeth

Sea Snake

They don't bite.

"Every time I go to the Alofi wharf
I see a Katuali, I won't jump off
and am too scared even though
I know the won't bite."
– CA

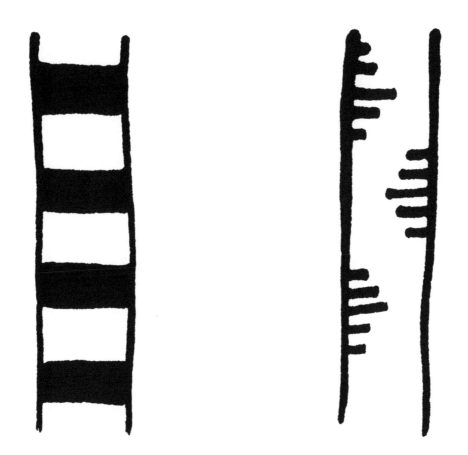

Katuali - Sea snake

Loli Uli – Sea Slug

"You can rub the loli into the sand
to soften, clean the inside and soak
it in lemon to cook."
– Nana

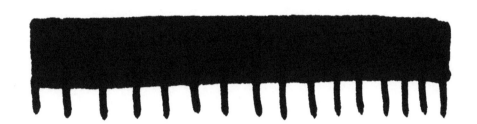

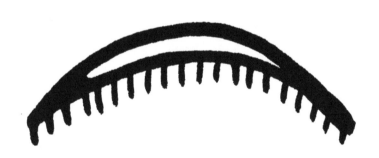

Sea slug

Kamakama – Crabs

Kama kama - Crabs

Used for broth and soups.

"There is a special season where you
are not allowed to swim in the ocean
because people are trying to catch the
Kaloama. It is a popular fish to
catch and cook."
– Nana

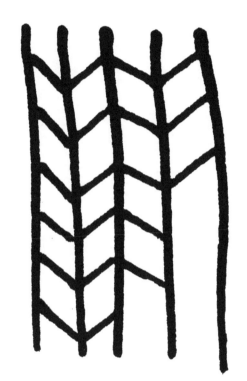 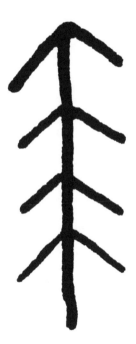

Fish bone

Fua Pule

Make a small kahoa attached
to a hair braided belt.

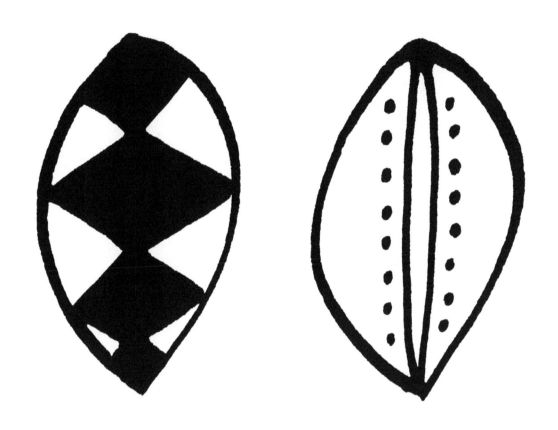

Cowrie shell - Fua Pule

WEAVING
AND
CARVING

Lalaga Potu

Lalaga Luli

Lalaga Kato

Makini Hall is a womens craft group right
across the road from the back packers in Alofi.

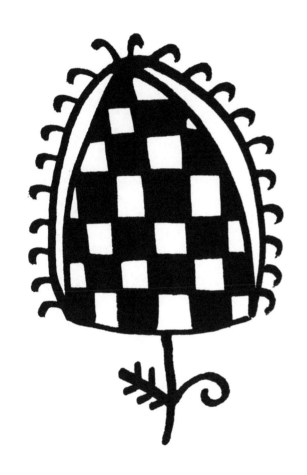

Lalaga - Fan

Lalaga borders

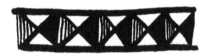

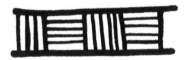

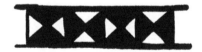

Banana trunk

Plant borders

Papahi

Laufusi

Tuga e Mouga

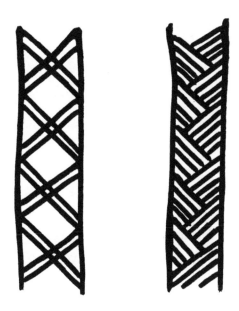

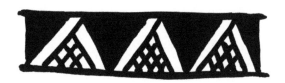

Carving borders

Patterns used on the Vaka,
also shapes seen in weaving.

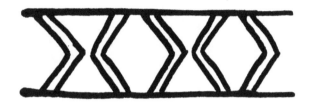

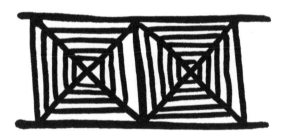

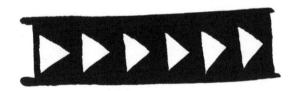

VARIETY

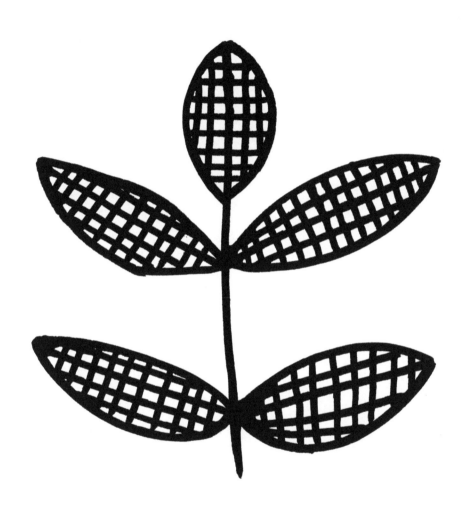

Ti

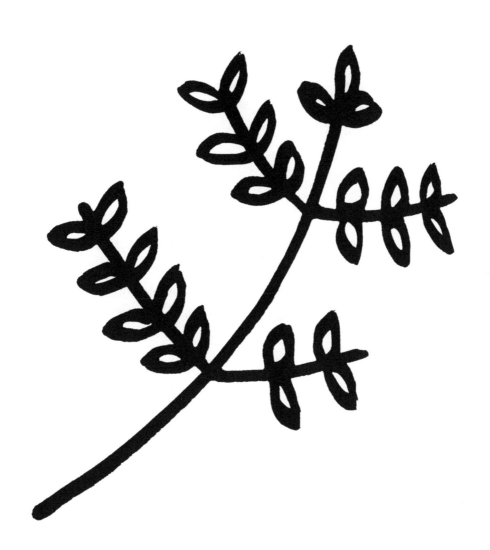

"Me and my dad went hunting at night
when it was raining. He made me
wait by a tree while he went into the
bush. I was scared and fell asleep."
– Nana

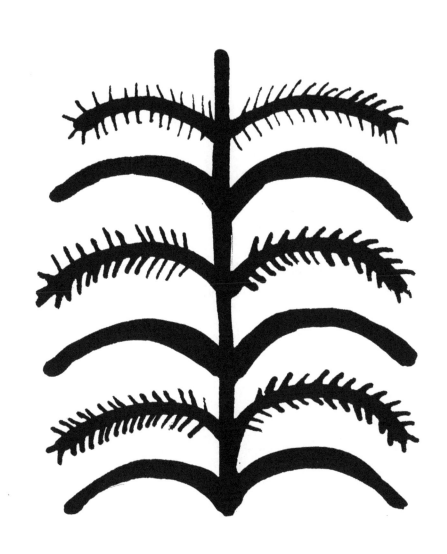

"We use to use a stick to poke at the rock pools."

– Nana

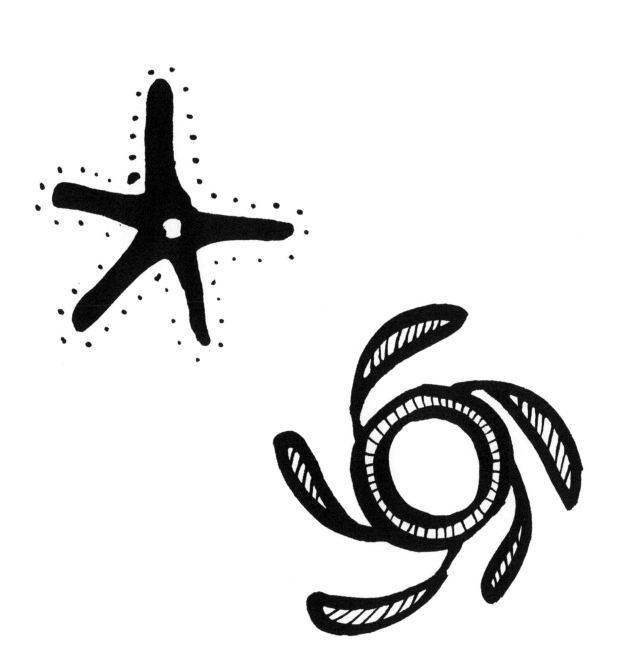

"I remember having to help cook the food
with my father for the prisoners. He was
a policeman – Ikivale Mohemana."
– Nana

Fono kula - Prison

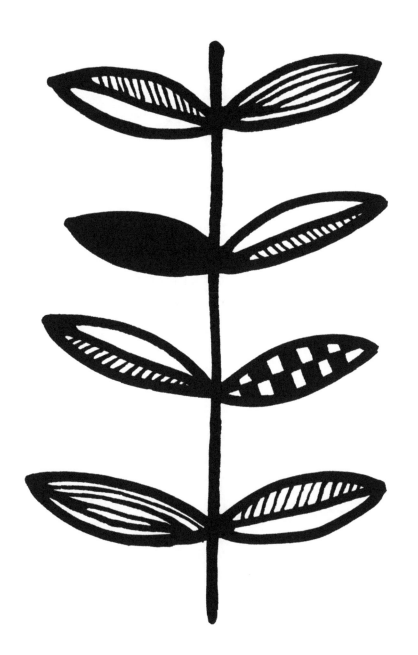

"Hiapo is the collection of many plants,
almost like maps they reflect
Niue and the landscape."
– CA

"When I was staying at the Richardson house, Ian pulled a hibiscus branch and wasps flew out and stung me in the face. I was stung three times."

– CA

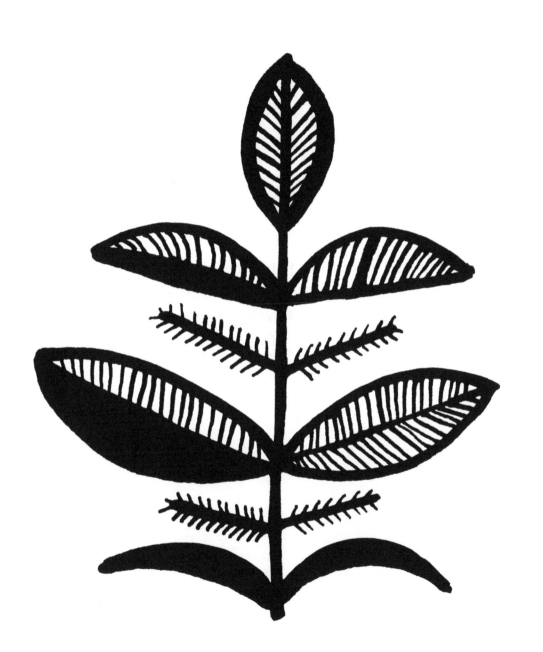

"When I was staying at the Richardson house, Ian pulled a hibiscus branch and wasps flew out and stung me in the face. I was stung three times."
– CA

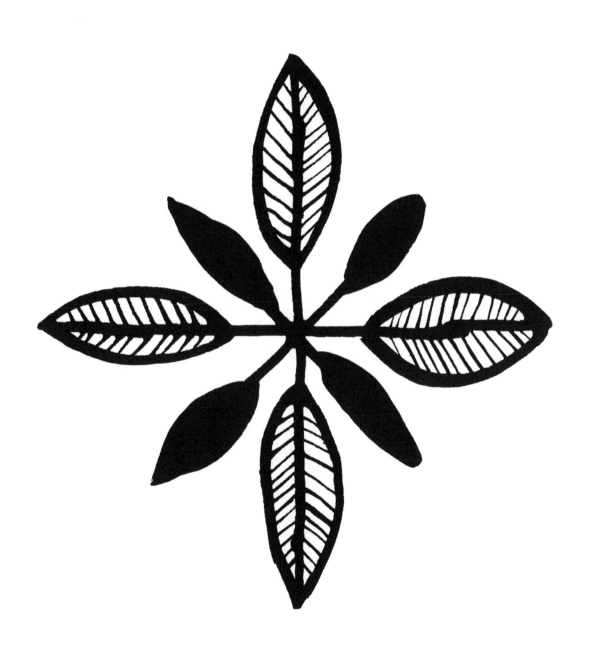

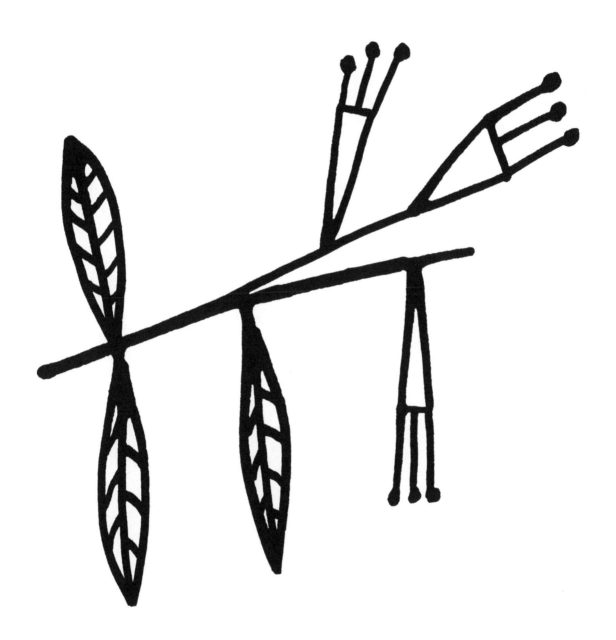

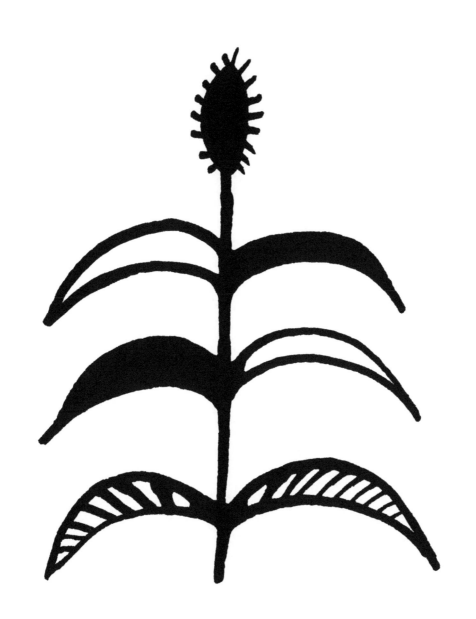

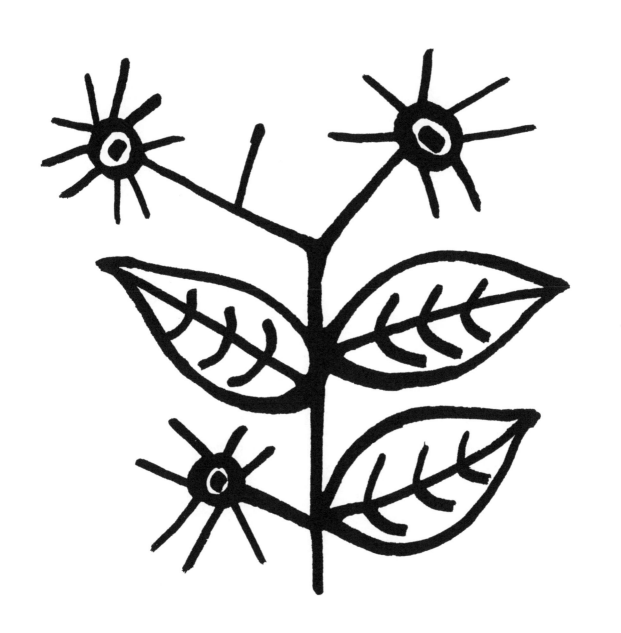